April 2003

For Emma Kay,
from the
National Gallery of Art
Love, Gramma
Sandy

MARIE
IN FOURTH POSITION

The Story of Degas' "The Little Dancer"

by **Amy Littlesugar**

illustrated by
Ian Schoenherr

Penguin Putnam Books for Young Readers

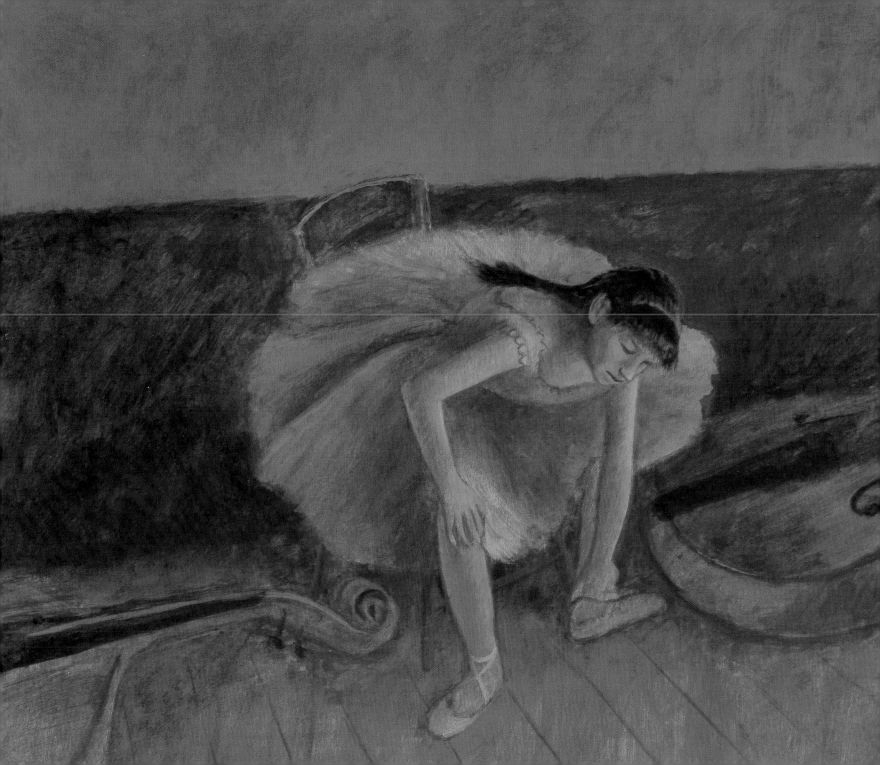

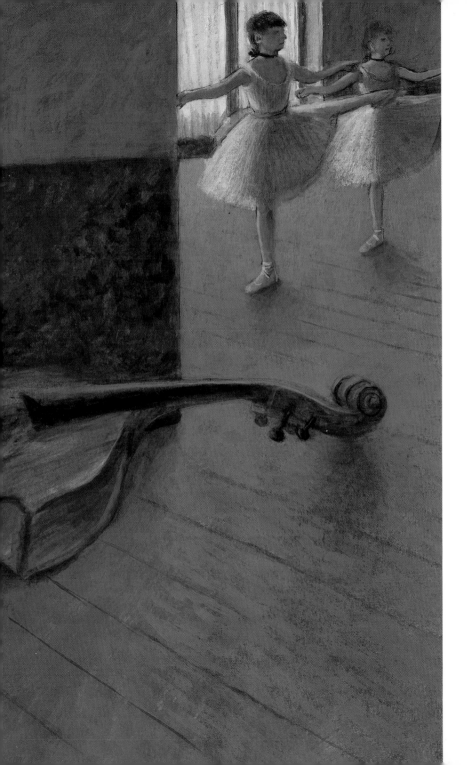

There once lived a girl named Marie who was but a "rat" in the Paris Opera.

Day in and day out, she danced as hard as the main ballet girls, her muscles aching, her feet bruised at times, but Marie was never noticed. Perhaps, she thought, it was because she was so thin and awkward for a dancer. Or that she had a face which looked better in the shadow of the chorus. Whatever it was, Marie believed that the chorus was where she would remain forever.

One evening when her mother, a laundress, returned home from yet another day of hard work, she said to Marie's father, who was a tailor, "You need thread for your spools and oil for the lamps. Marie will have to go and work for Monsieur Degas, the artist. His housekeeper says he pays well."

Then she called Marie and told her that Monsieur Degas was in need of a ballet student to model for some drawings.

"*Oui*, Maman." Marie knew that she had no choice. Not with Maman. Besides, she had washed and pressed Marie's best leotard.

But of Monsieur Degas, Marie had heard much!

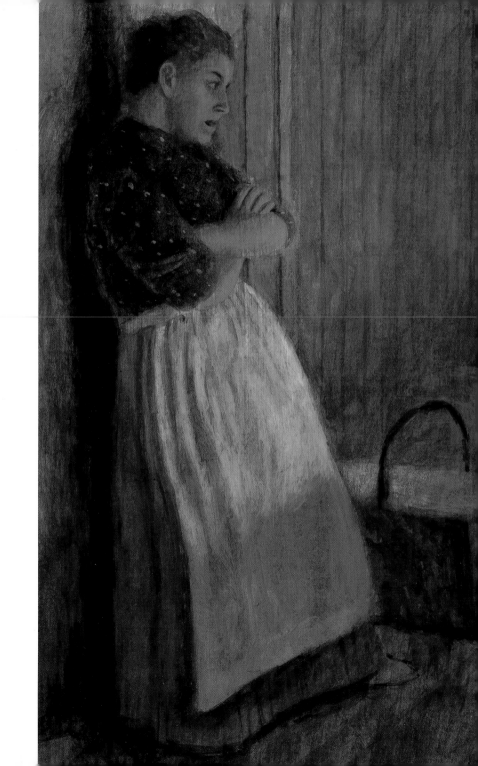

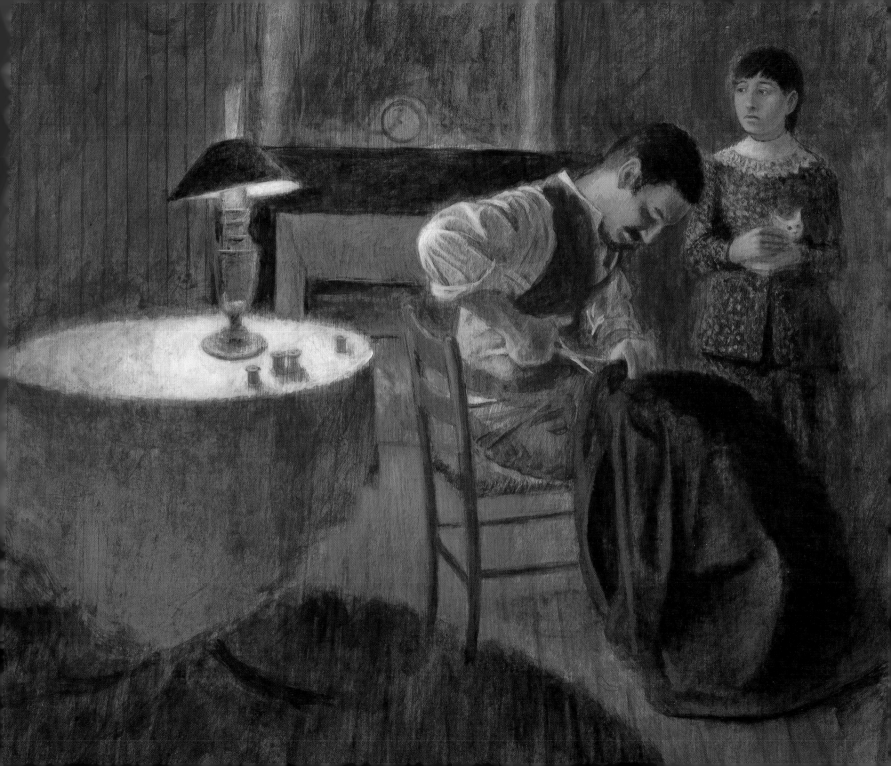

Only last week she listened as several ballet apprentices called him "Monsieur Terrible."

"To model, he makes you stand on one leg like a bird for many hours!" one girl whispered.

And it was well known about the Paris streets that Monsieur Degas could be mean and disagreeable, going about with his walking stick, poking at boys and dogs alike, and shouting at carriages that dared to pass before him.

Even the ironer several streets over found him odd.

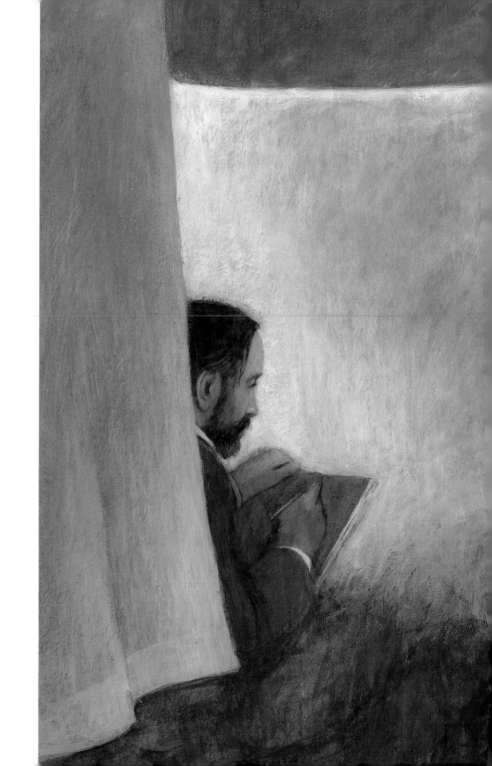

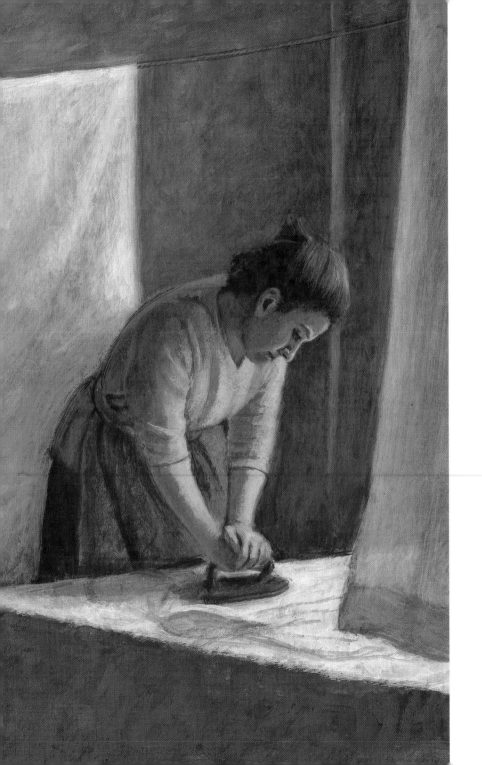

"Monsieur Degas sketches me before the window when the sun is quite fierce. He tells me how my hands and arms make wonderful shapes as I press the iron! I am wilting with heat, and he says, 'All the better! That is what I wish to see!' One day I will scorch a shirt posing for him! Mark my words!"

Monsieur Degas' paintings were filled with ordinary people, bending and stretching to get their work done.

Now he needed a little ballet girl. Just like Marie.

The next day, Monsieur Degas' house-
keeper came for Marie.

Madame Housekeeper wore a black shawl
over a clean white apron. A large ring of
keys dangled at her waist. She looked
very serious.

"Come, child," she said. "Monsieur Degas
is waiting."

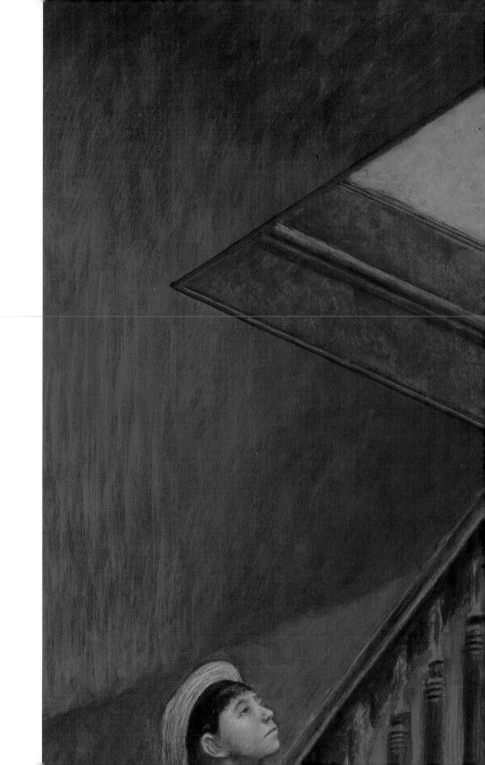

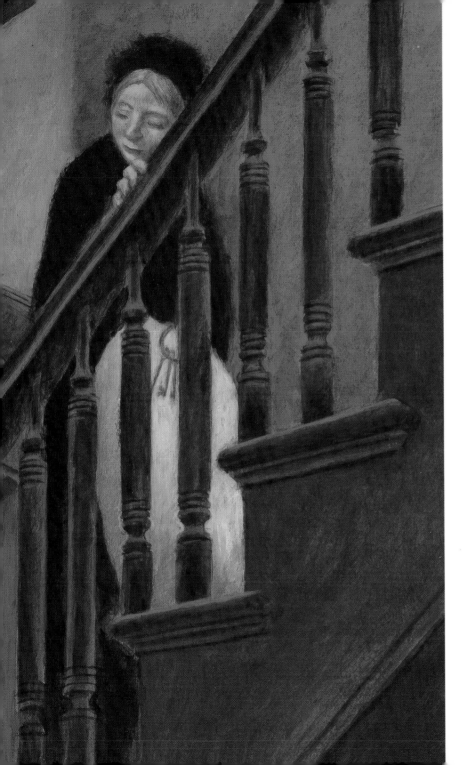

They walked briskly along the narrow Paris streets, until they came to a tall house at 19 Rue Fontaine. Up, up, up they went to the *atelier* of Monsieur Degas, and with each step she climbed, Marie was determined to be brave.

Suddenly, Madame's keys ceased to jingle.

"Here we are," she said, unlocking a heavy door and sweeping Marie into a room filled with window light.

Marie had never seen anything like it. Her heart soared. Everywhere she looked were surprises in this amazing brightness. In one corner, a handsome orchestra conductor's podium rose, tall and stately. In another, a broken easel leaned against a torn velvet chair. A stringless violin bathed in a shallow tub, and all around the room, the walls were thick with canvases of people, some of whom Marie was sure she recognized.

And there was Monsieur Degas himself, in his artist's smock and cap. Small, mysterious, his eyes were dark pools of secrets.

Monsieur Degas bowed deeply. Without a word, he took her hand and led her to a modeling stand.

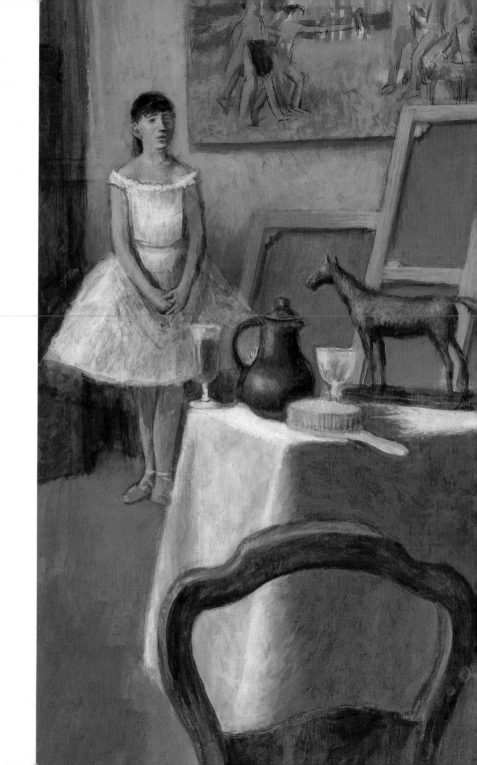

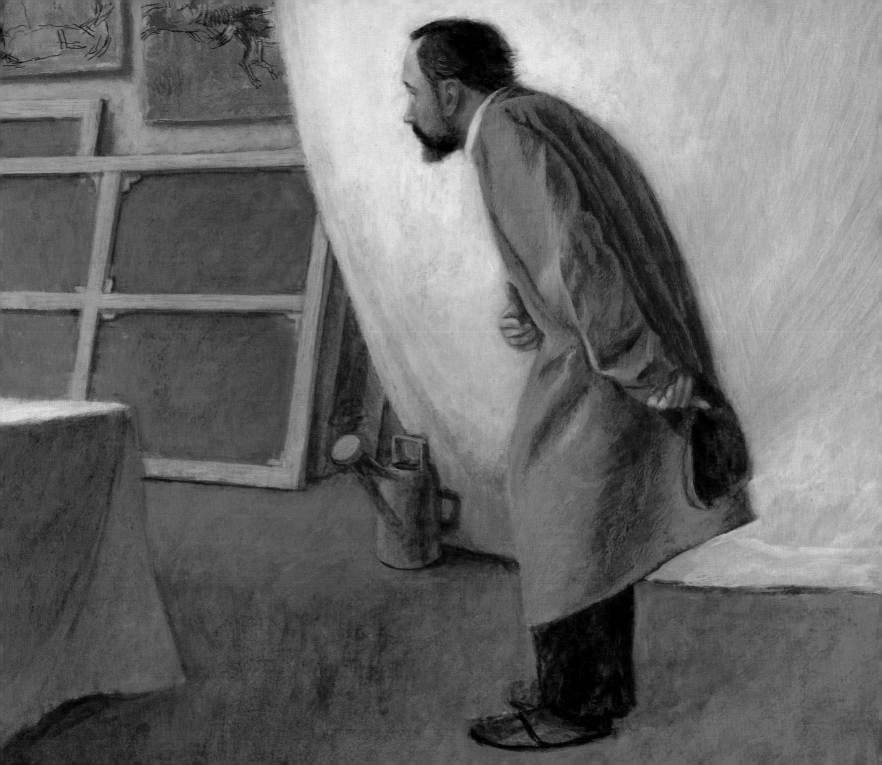

"Will you step up, please?"

He sat somewhat below her, very close to his easel.

"Now, Mademoiselle! I wish for you to look as though the spotlight of the ballet shines on *your* feet alone."

"Pardon, Monsieur," said Marie hesitantly. "But I do not know how to look like that." Didn't he know she was only a rat in the Paris Opera?

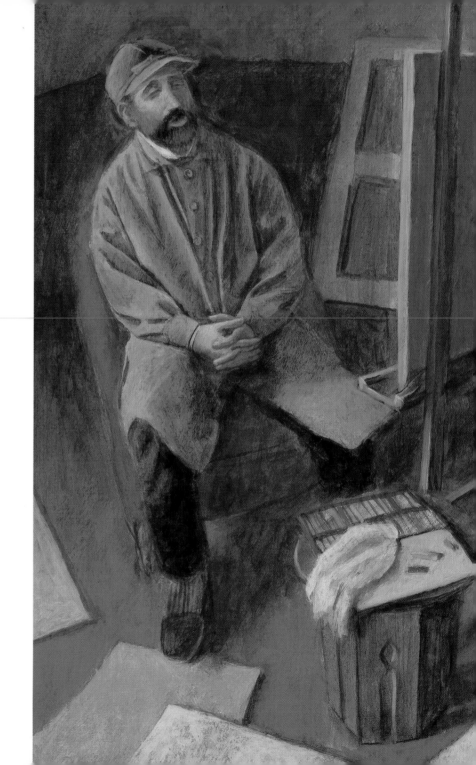

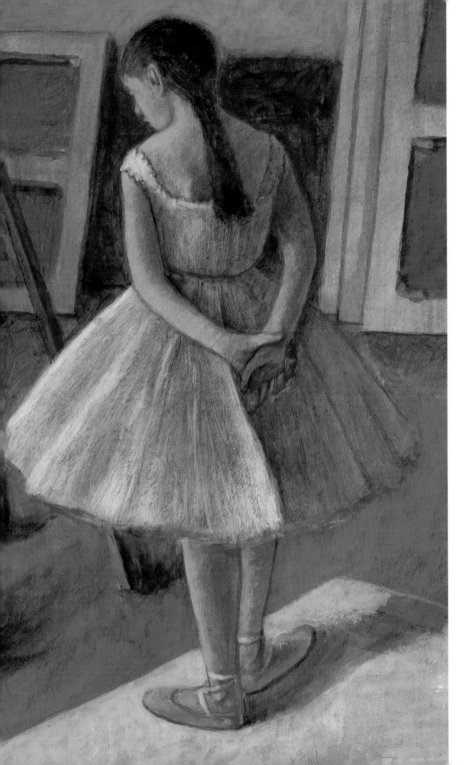

"Hmmm," said Monsieur Degas, studying the pigeons on the ledge outside the window.

"Mademoiselle." He turned. "We will give each other a small gift, *n'est-ce pas*? You will give me a pose that Paris will never forget, and I will teach you to have an imagination!"

"*Merci*, Monsieur," said Marie.

But after the first day, Marie found it was not so easy.

"*Non, non, non*, Mademoiselle!"
said Monsieur Degas. "That pose is
clumsy and will not do!"

Poor Marie. It was a miserable afternoon.
And the next was even worse.

"Come, Mademoiselle!" he spoke sharply.
"Turn your head! More! More!"

Marie could not hide her tears.

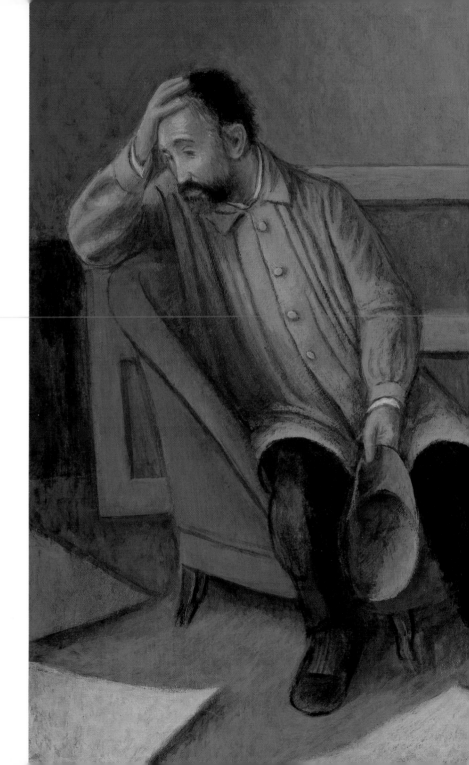

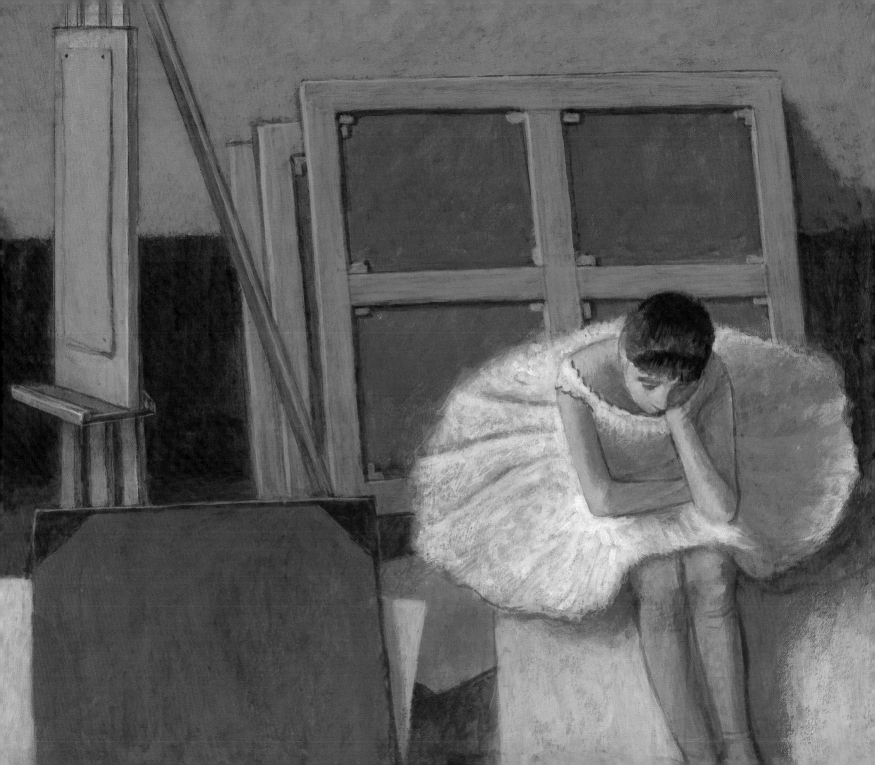

On the third day, Monsieur Degas met Marie at the door. Gently, he took her fingers and led her to the modeling stand.

"*Ma fille*," he said, "the pastel is like the powder on a butterfly's wing ... and you are the butterfly!"

Marie took a deep breath and climbed once more into the same pose.

"Look up," said Monsieur Degas. "Higher. Higher! As though you wish to fly!"

Marie tried. Oh, how hard she tried.

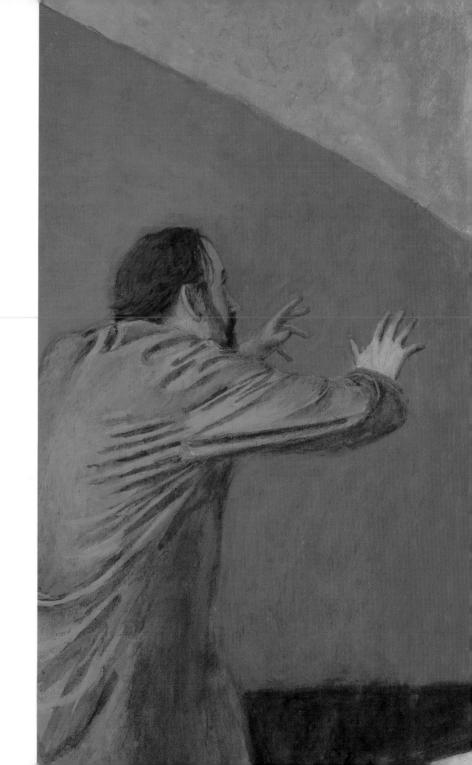

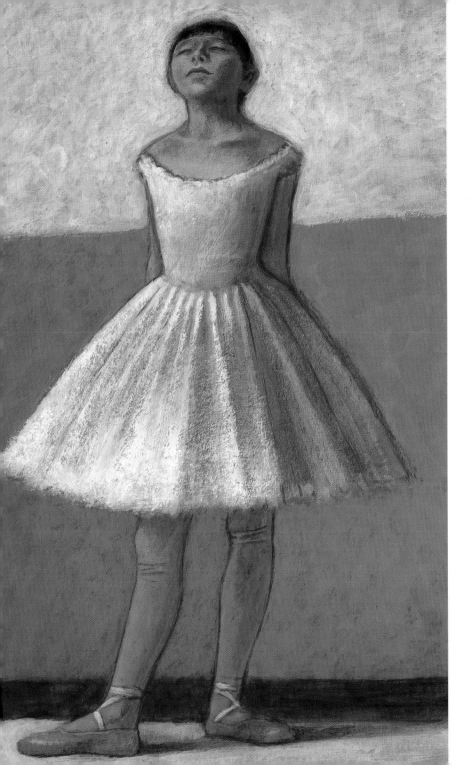

"Imagine," said Monsieur Degas,
"a flower cart outside the Place de l'Opéra.
It is filled with roses. The sweetest roses!"

Marie closed her eyes. She was a soft
yellow butterfly visiting many flowers.

Stretching, stretching, stretching,
she clasped her hands behind her back.
Her right foot slid firmly into place.

"That is it," said Monsieur Degas.
"Do not move!"

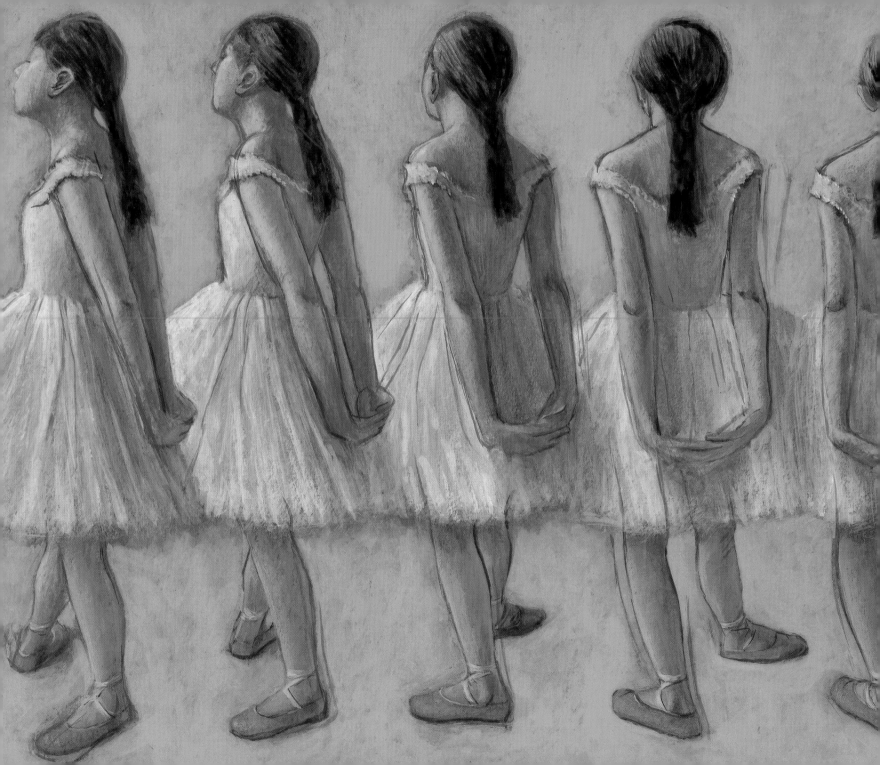

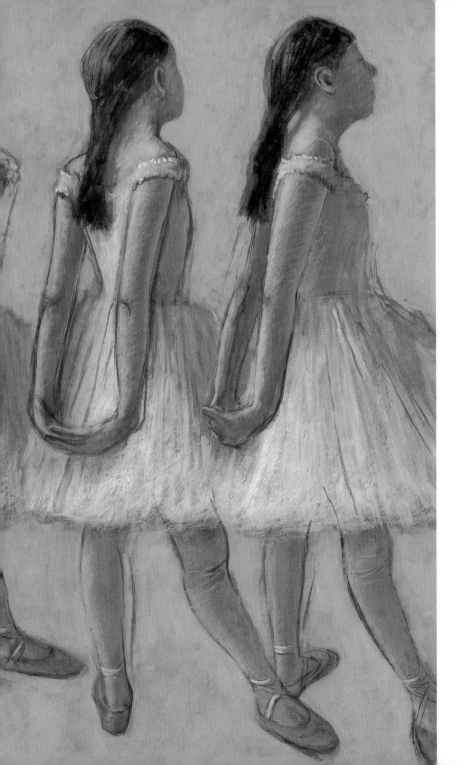

At once he seized his chalks and began drawing at a dizzying speed. Sheet upon sheet of colored paper flew about the studio. His chalks became worn down to no more than stubs. But Monsieur Degas was an artist capturing a living moment. He could not let go. With one last burst of color, the chalks streaked across the apple-green paper, marking just the right wrinkle in Marie's stocking.

Finally, Monsieur Degas put down his chalk.

"*Bien,*" he said, quietly. His eye caught a faded dancer's bouquet on the windowsill. One last bloom strained toward the light.

This he offered to Marie.

"Dance," he told her. "Love only that. Let dancing be your life."

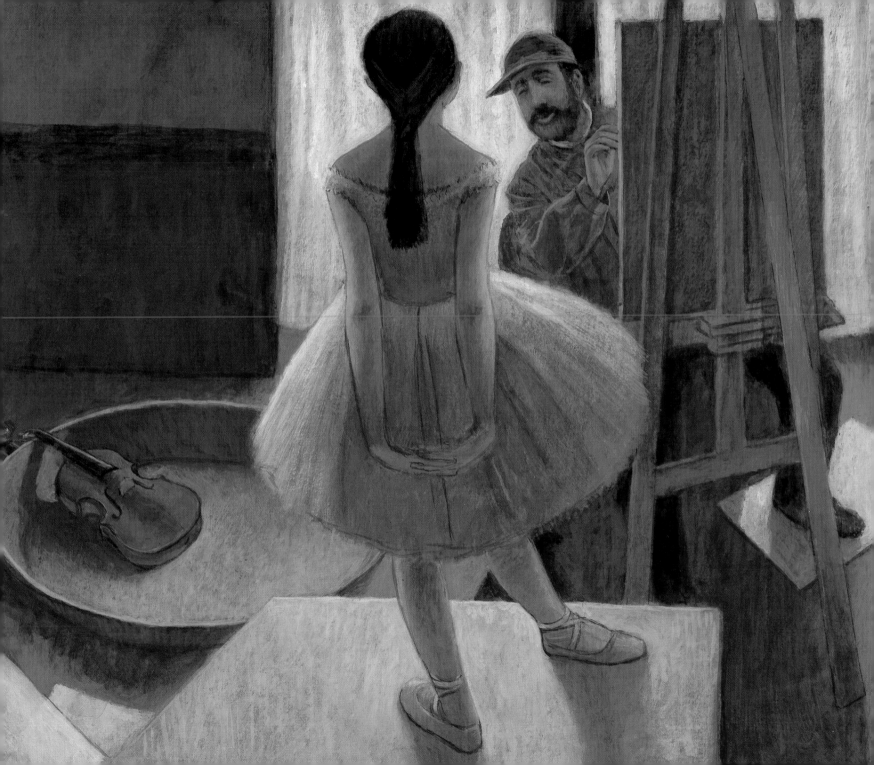

Now Marie looked forward to her visits
with Monsieur Degas. Over and over he
drew her in this same perfect pose:
what the ballerinas called the Fourth
Position. But Marie never tired.
She was too busy listening to what his
chalks asked of her. The slightest turn
of her head, the twist of one slipper,
made Monsieur Degas say,

"La Belle Marie!"

And Marie thought, "He is not
'Monsieur Terrible' at all."

Then one day, Madame Housekeeper did not come for Marie. Nor the next. Although she wondered why, Marie's mother told her she must not think about it.

Instead, she put her mind to her ballet practice at the Opera. There everyone took notice.

At the barre, her pliés were perfect every time. She even caught the eye of the old dance master.

"*Magnifique!*" He clapped. And the other apprentices in the chorus remarked, "Have you seen Marie lately? How is it that she dances so well?"

Marie kept her secret. She was no longer a rat but a butterfly, after all. Yet she wondered, where was Monsieur Degas?

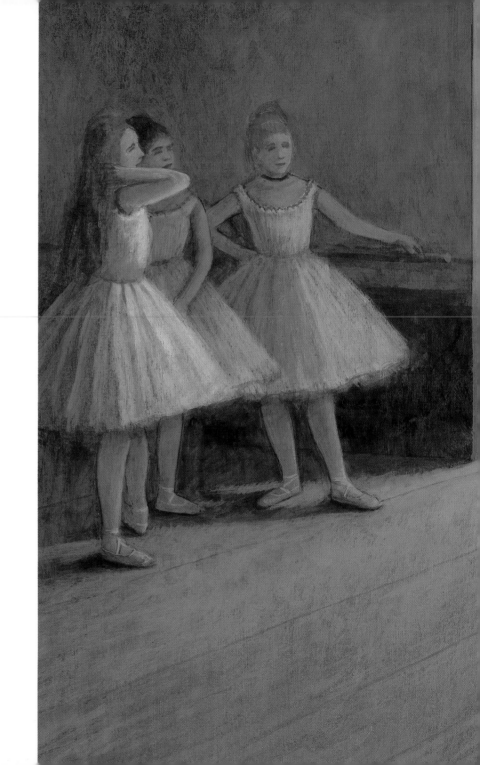

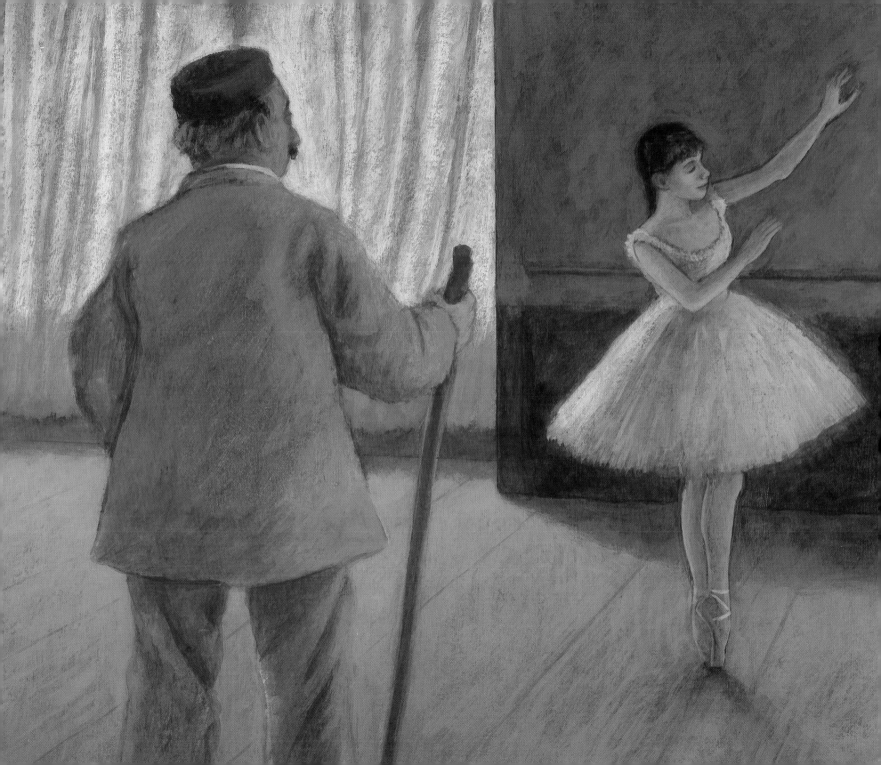

Monsieur Degas was very busy
in his studio.

Gathering together all the drawings he
had made of Marie, he decided to
make a sculpture from them.

Fingerprint over fingerprint, he modeled
it out of wax that he tinted to the color
of Marie's skin. It became the size of a
large doll. It was almost living. But
not quite.

Monsieur Degas put on his top hat and
strolled down a boulevard with an
address in his vest pocket.

From one Madame Cusset, a maker of
doll's hair, he purchased what he
needed. Then he bought a linen singlet,
a gauzy skirt, and a pair of satin
dance slippers.

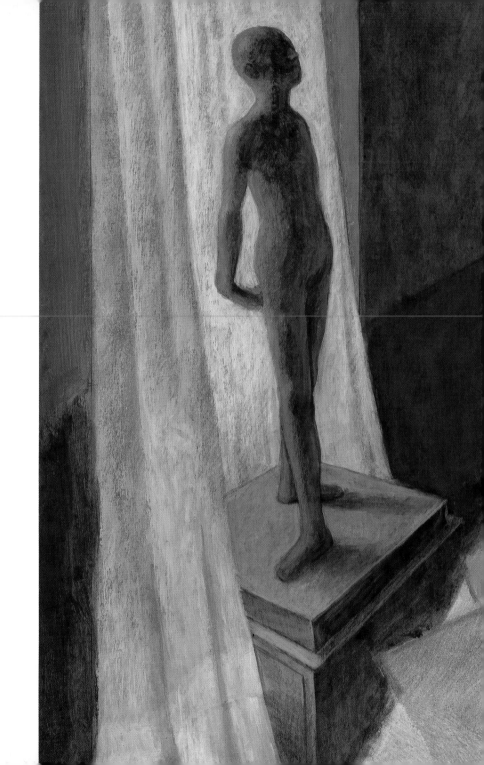

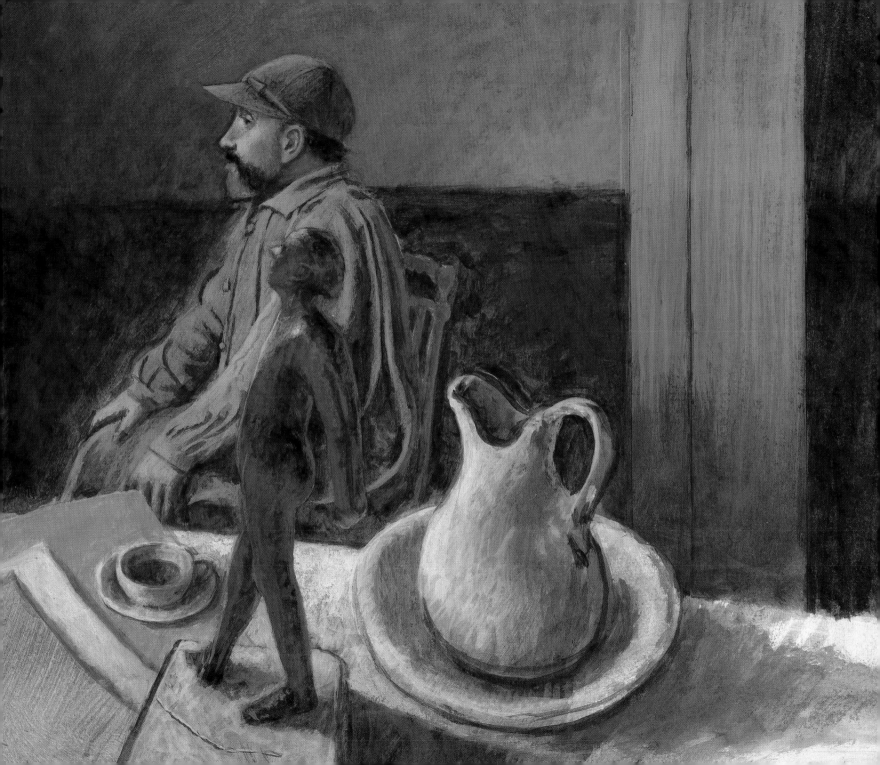

He dressed "The Little Dancer," as he called it. And he said to Madame Housekeeper, "I need something more. A hair ribbon. But what color?"

Madame had just come from market. Peeking out of her basket was bread, a chicken, and the grass-green tails of a bunch of leeks.

"Ah," said Monsieur Degas to the leeks. "*Le porreau,* of course!"

"The Little Dancer" was finished. None of this did Marie know.

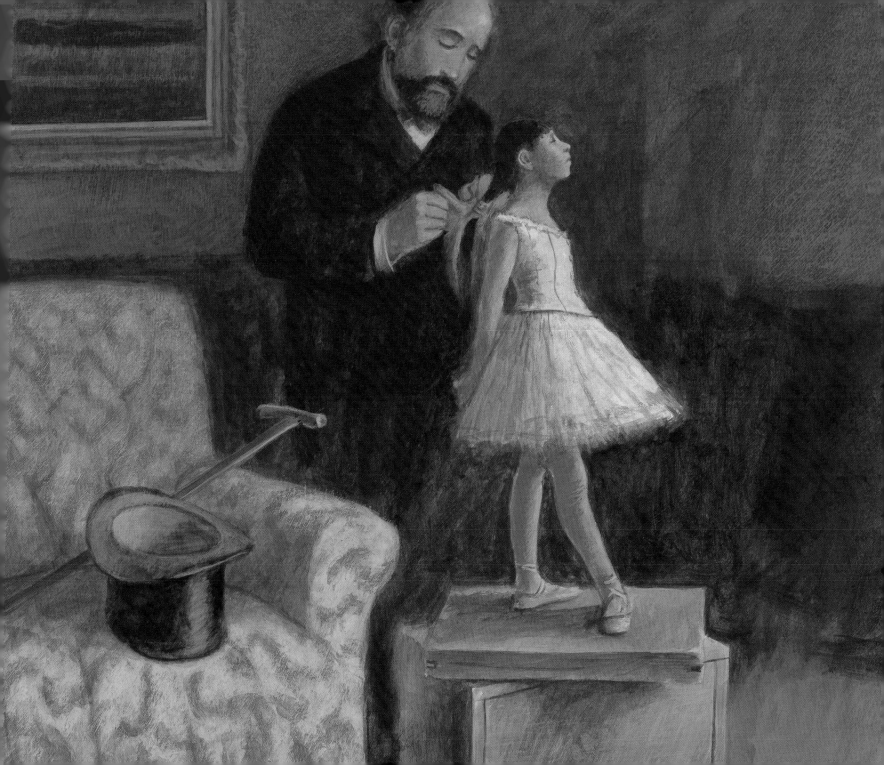

In April, Monsieur Degas entered this sculpture in the sixth Impressionist exhibition of 1881. He was not sure how it would be accepted — "The Little Dancer" was nothing like the smooth marble figures the world was accustomed to. Still, he had to find out.

So it was placed in a glass case all its own, like a jewel from some ancient culture.

It made Paris whisper! Monocles were raised and newspapers buzzed!

None of that mattered to Monsieur Degas. Marie had given him a magnificent pose, and he could ask for nothing more.

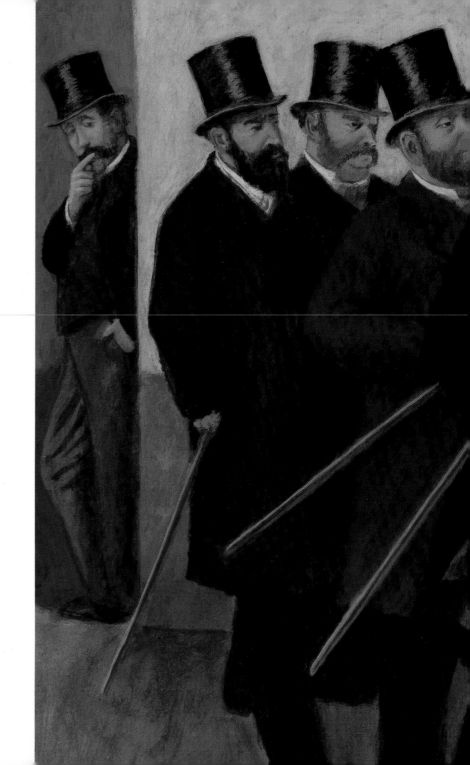

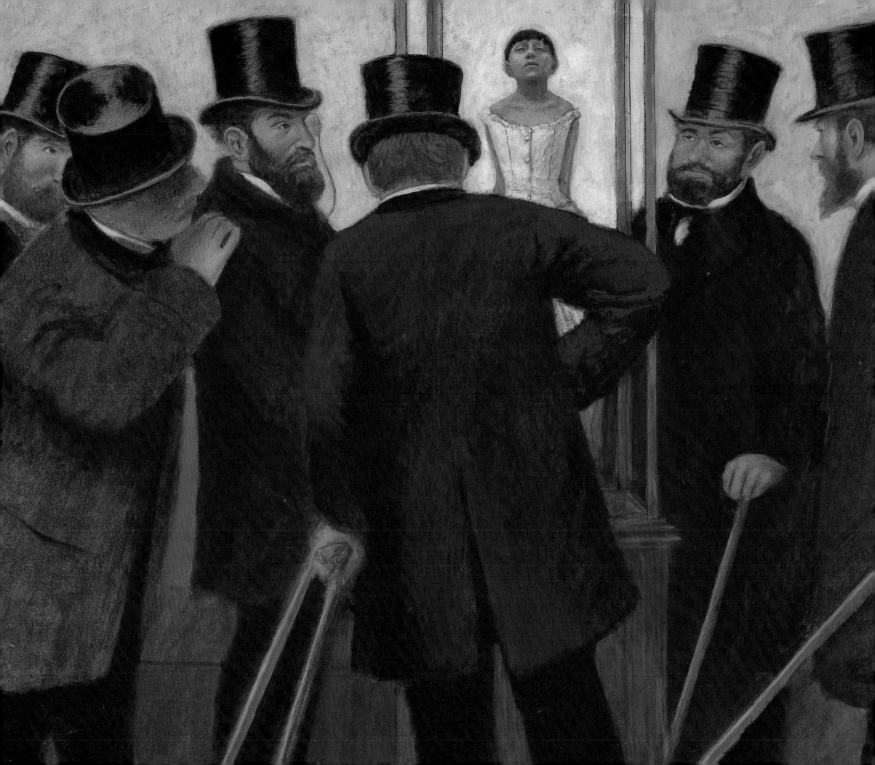

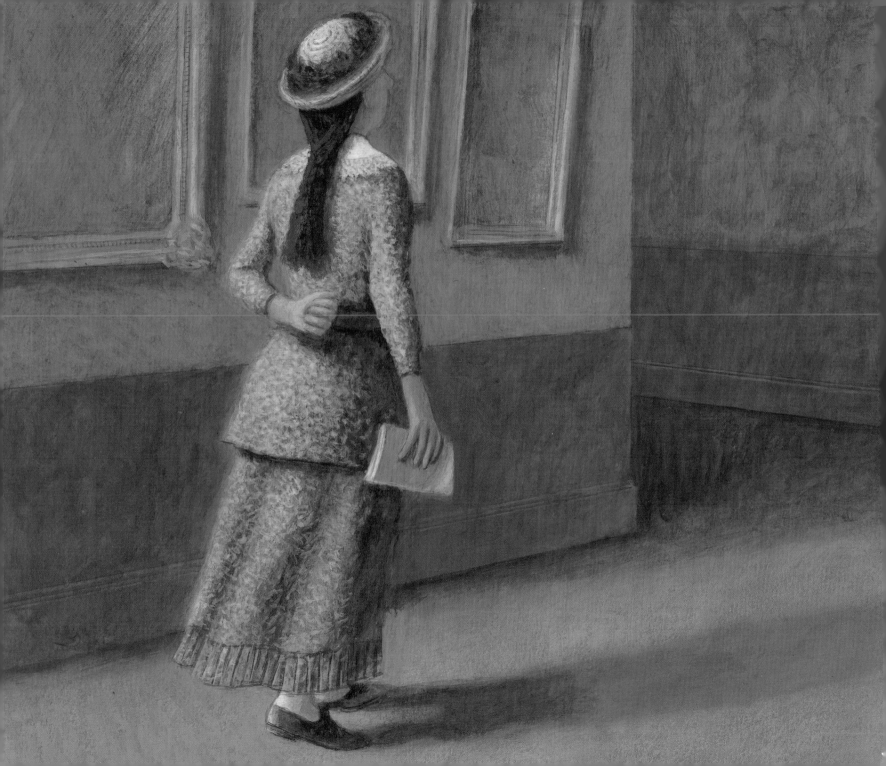

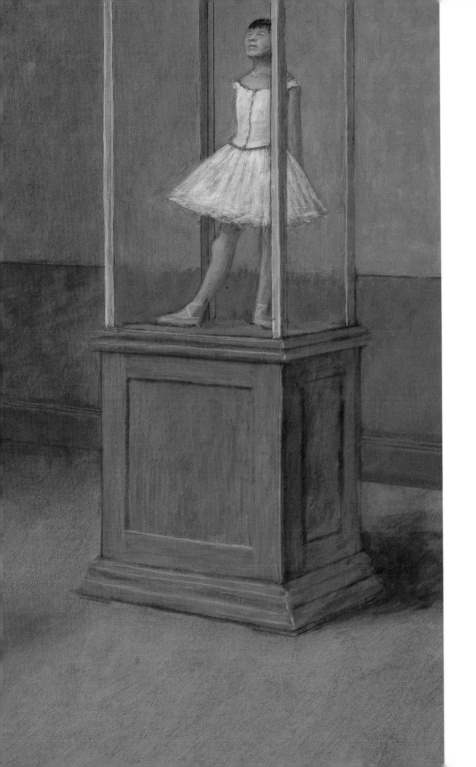

As for Marie of the Rue de Douai? Did she visit the sculpture? Did she marvel at its grace? No one knows.

One thing is certain. Forever after, all over the world, she would be known as "La Petite Danseuse." She had succeeded in becoming a butterfly.

Author's Note

Between 1879 and 1880, a poor ballet girl named Marie van Goethem posed for the French painter Edgar Degas. She was painfully thin and not pretty, but Degas didn't care about that.

He would draw her many times, from many angles, in what dancers called the "fourth position."

Yet a drawing is a flat surface. How would Monsieur Degas show the arch of her back, or her hands clasped tightly together? How would people see Marie's long black hair? Degas already knew—sculpture.

He began with a wire base, almost as big as Marie, and covered it with wax. Then he went a step further, surprising everyone who saw it at the Sixth Independent Exhibition in Paris. Dressed in real silk and satin, wearing real hair and slippers, Marie came to life!

As I wrote this story, I wondered if Marie ever had the chance to see the sculpture of herself. There's no record that she had. Nevertheless, I imagined her weaving her way among her onlookers who had so much to say about "La Petite Danseuse," and smiling. For just as Monsieur Degas had promised, she had given Paris a pose that would never be forgotten.

For David, again. And to Patti, for the journey.—A.L.

To Gabe and John, who posed for me.—I.S.

Originally published in 1996 by Philomel Books. Published simultaneously in Canada. Manufactured in China
Library of Congress Cataloging-in-Publication Data
Littlesugar, Amy. Marie in fourth position: the story of Degas's "The litte dancer" / by Amy Littlesugar; illustrated by Ian Schoenherr. p. cm.
Summary: After she models for the artist and sculptor Edgar Degas, Marie feels transformed into a butterfly and becomes known all over the world as "The Little Dancer."
[1. Ballet dancing—Fiction. 2. Degas, Edgar, 1834-1917—Fiction.] I. Schoenherr, Ian, ill. II. Title. PZ7.L7362Mar 1996 [E]—dc20 95-40827 CIP AC ISBN 0-698-11769-7
10 9 8 7 6 5 4 3